Essence

Corinna Stoeffl

Essence

contemplations in image and word

Corinna Stoeffl *and* Stewart S. Warren

AuthorHouse™
1663 Liberty Drive
Bloomington, IN 47403
www.authorhouse.com
Phone: 1-800-839-8640

First published by AuthorHouse 02/22/2010

ISBN: 978-1-4490-7825-6 (sc)

Library of Congress Control Number: 2010902122

Printed in the United States of America
Bloomington, Indiana

This book is printed on acid-free paper.

Images on the front and back cover by: Corinna Stoeffl
Author portraits by: Carolyn D'Alessandro

author HOUSE®

For those who are well on their way,
and for those (like most of us)
who enjoy a few more reminders.

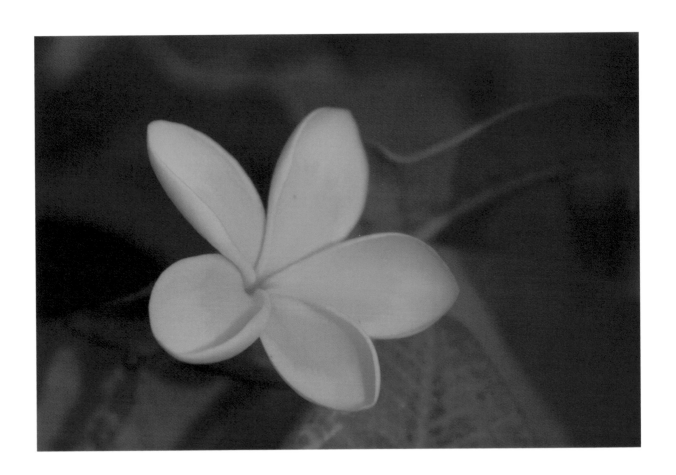

1

In silence
I make invitation,
allow allowing.

In the world
I am this
ever-full cup.

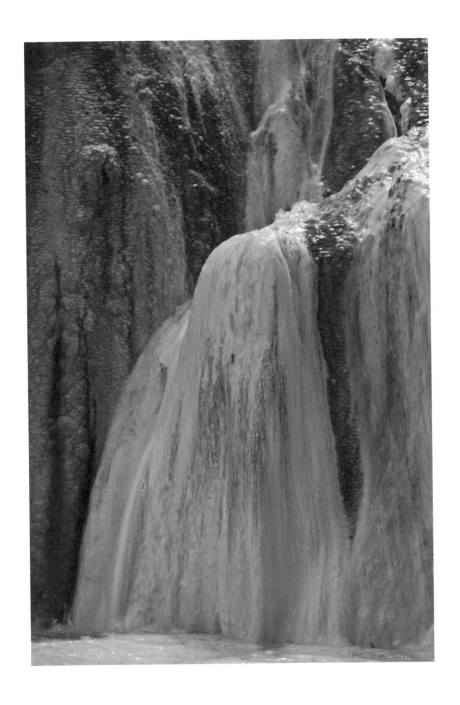

All those stairs to climb,
leaves and wings to examine,
stories belonging to others.

Look without language,
she said, here,
with a surrendered mind,
in the cascade of longing.

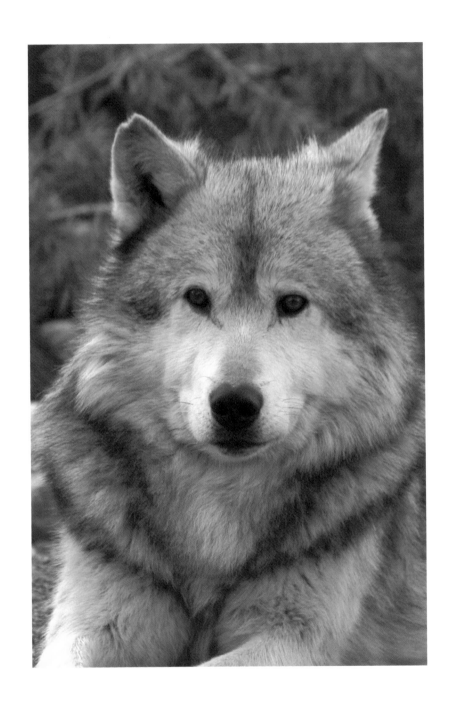

Don't pretend
not to know me,
our forest journey,
our crabwalk
on sand, celebration
of fins and feathers,

our moment
to moment decision
to play this game
round again.

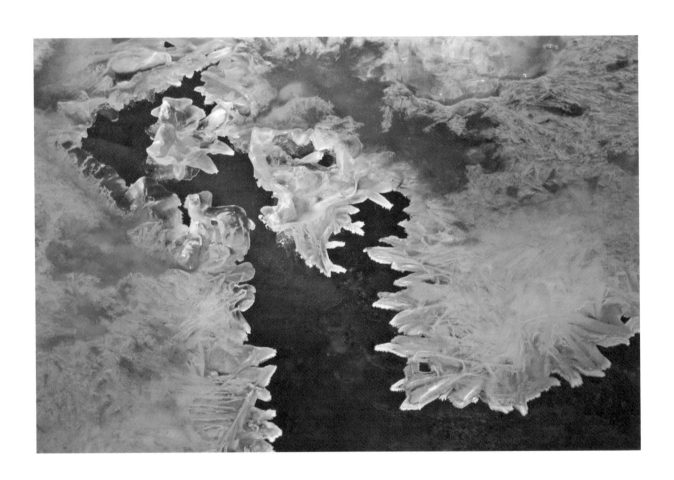

7

At the edge
I am always
forming, melting,
the crest
of creation.

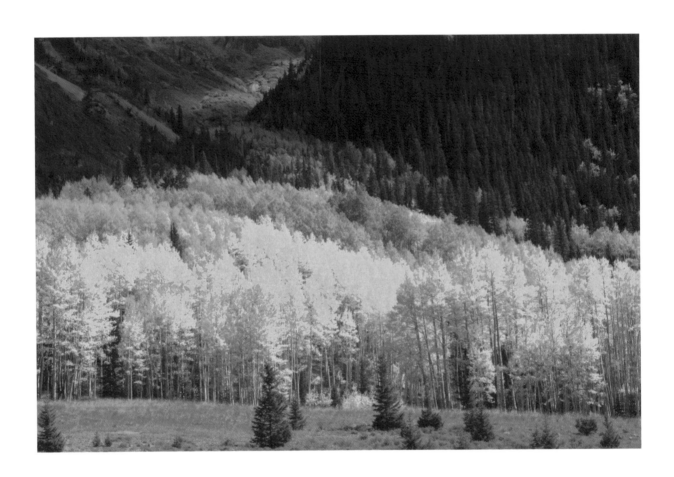

9

Not a distance,
nor destination,
something to push
in front of me,

but you—
closer than close,
a new way of seeing.

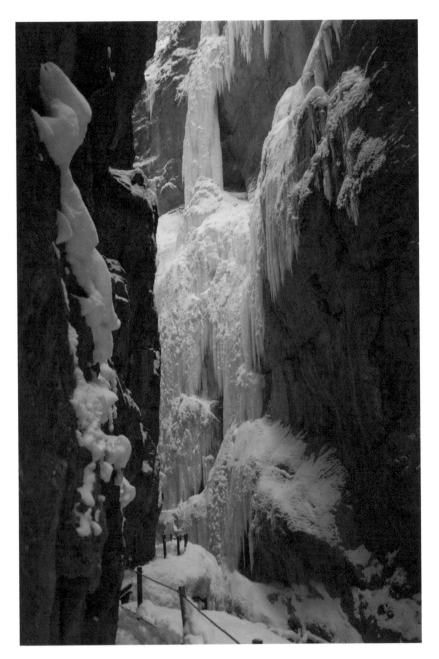

I wound my way
into the rock,

deeper and deeper,
night inevitably falling,
pulled or pushed

from within or without,
it no longer mattered.

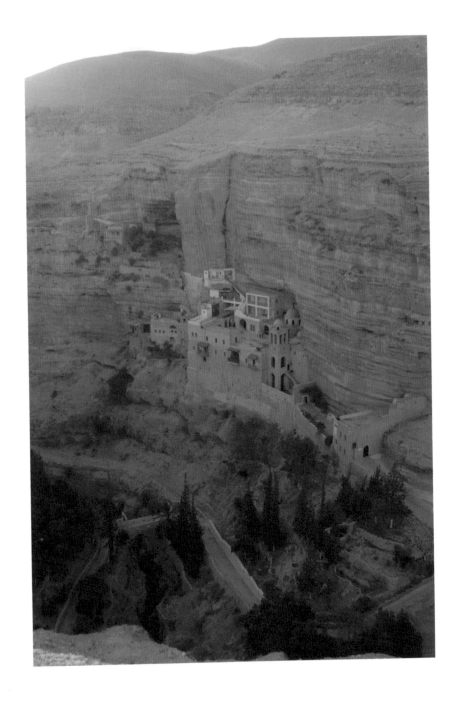

13

My nest is high
in the cliff.
I cling to the word

until nourished.
Then I fly.

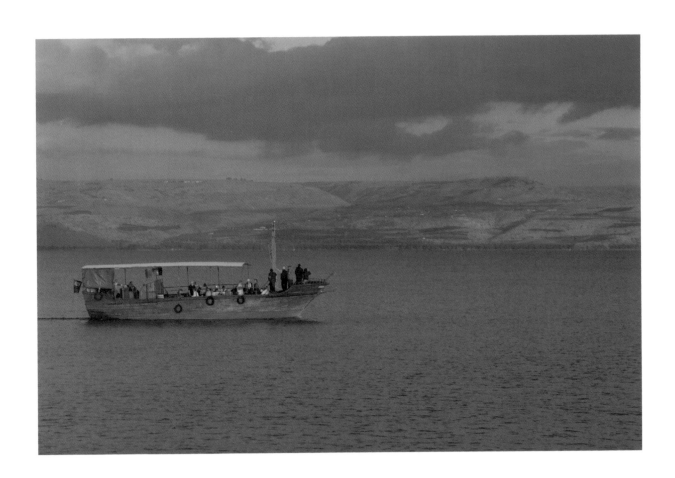

Not waiting
for your return
we set out
at first light.

With our desire
and our feet
firmly on the deck,
we cast
into one another's eyes.

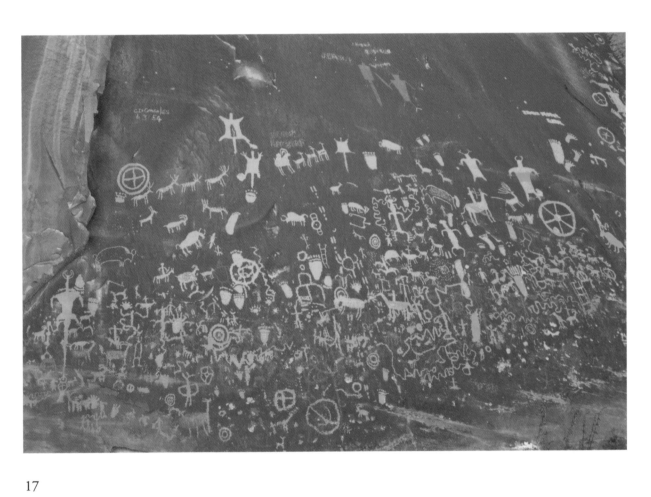

17

Whatever was
in my mind that day
fades with wind, rain;

the urge to connect
raising my hand
again and again.

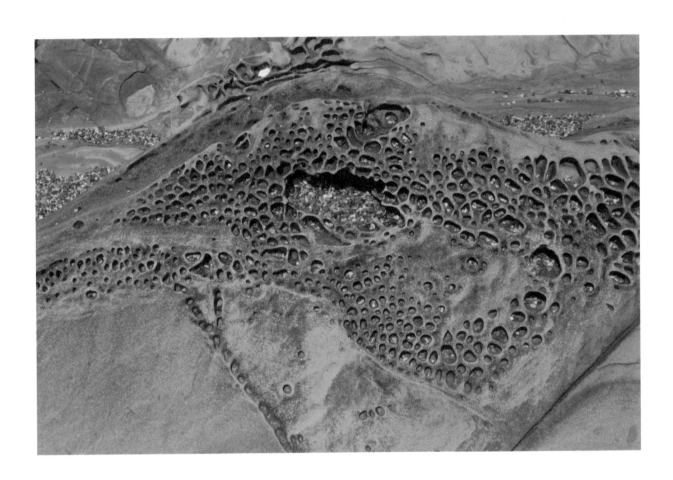

19

And where is that
place I look
when I find you?

Anywhere I look
when I look
from here.

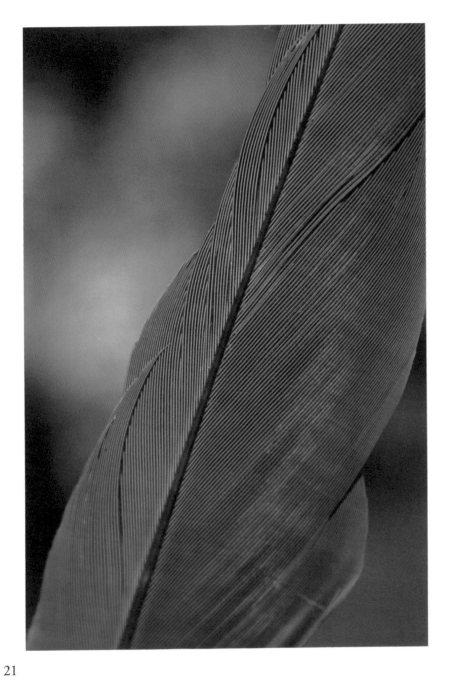

Each slice of air,
each sliver of breath
is a current twining
its singular way
into the clouds.

At night all these
scoops of sky
return to the field,
a flock bowing down
as one.

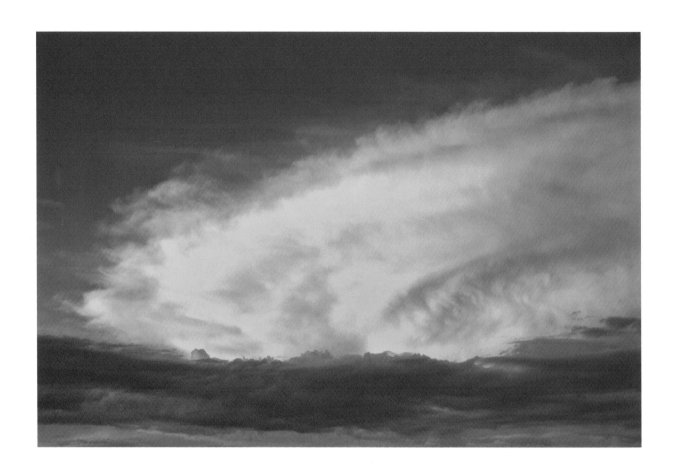

23

All day I worked
on the wheel,
grabbing at levers,
shouting directions,
making things go.

At sunset I leaned
on the rail and wondered,
Who beats this heart,
Whose face rises
everywhere I look.

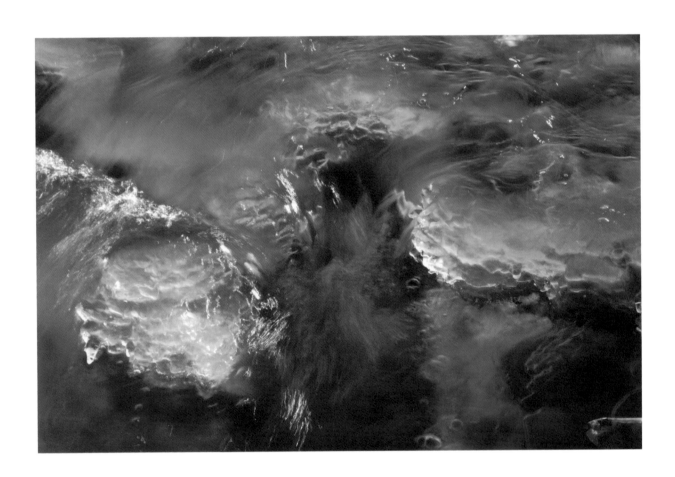

Not the dream:
this crystal-edged
glittery thought, but
the dreamer.

It is the dreamer
who dissolves, melts
into the silent roar.

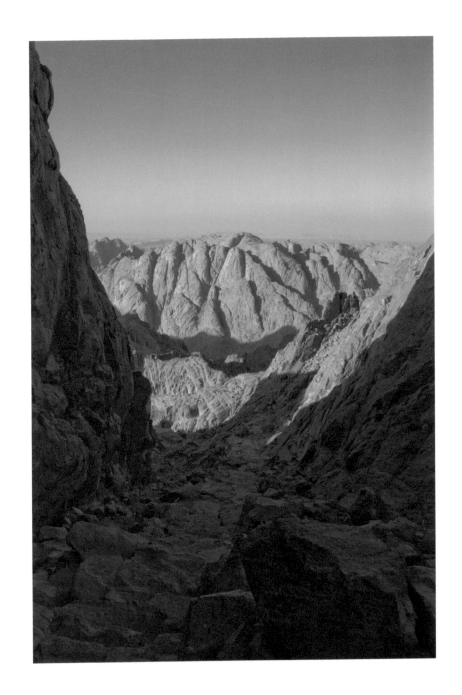

Sheltering me,
lifting me,
in every rock the earth
bursting forth,

urgently diverse.
In every moment
silence, presence.

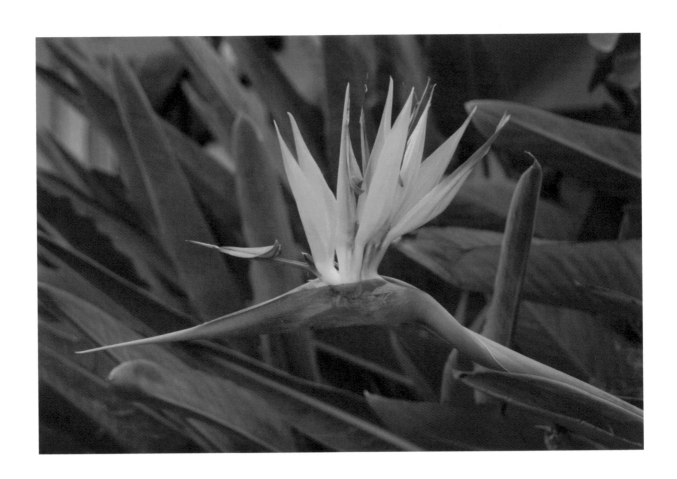

Such a sense of humor!
Lets see—today
I will be a thousand flowers
with curious faces.

Tomorrow, each leaf
will wake and decide
for itself.

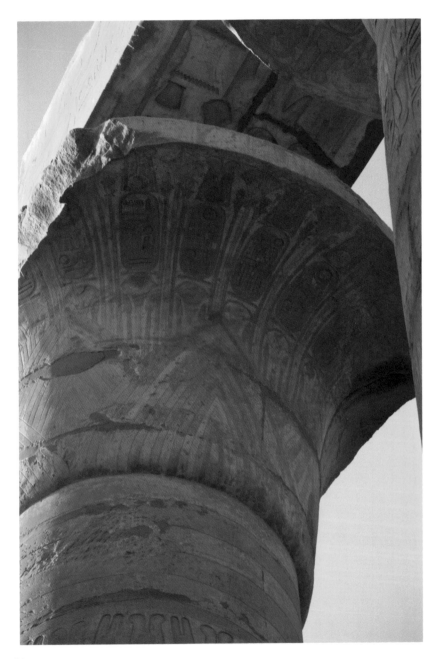

I follow the crumbling,
stories of saints,
illusive source and flame.

When I'm a pot hunter, a thief,
a hungry child selling gravel,
I get in my own way.

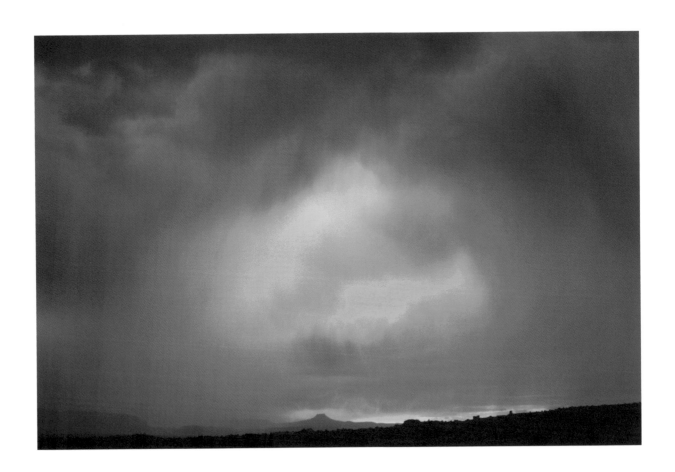

33

What business
is it of mine
how rain falls?
Today I have feet,
yesterday, fins, wings.

Perhaps I am
not these things,
perhaps
there is no end
to this delight.

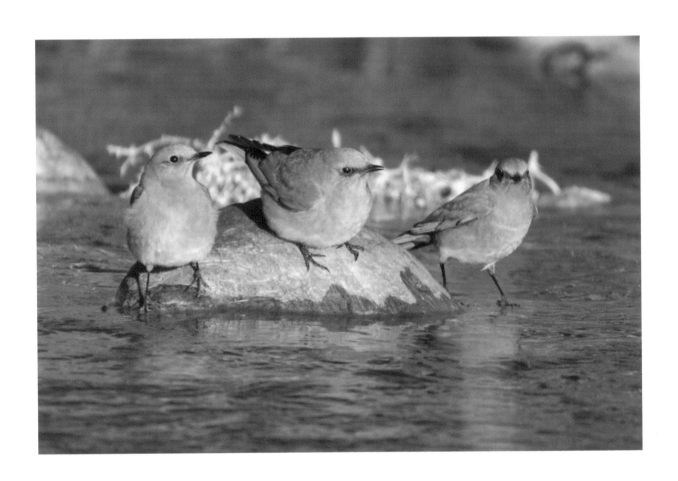

Living in the midst of it,
the exchange
is simply the song
we sing,

migrating with buckets
to the spring,
dipping for others,
passing our self around.

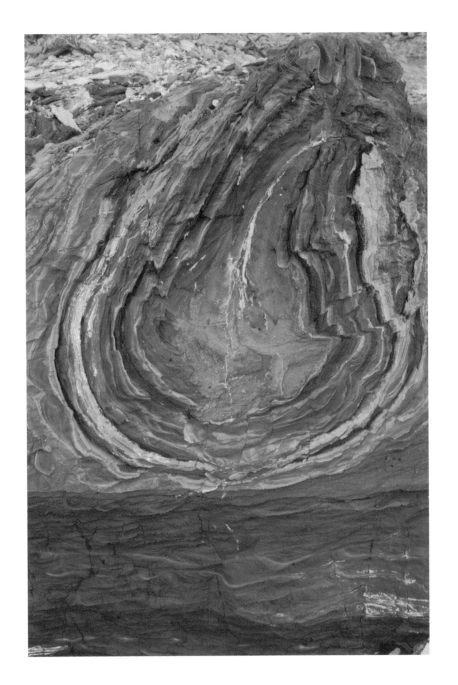

37

Plowed fields,
rolled-over ranges,
layers of creation,

stones
like grandparents
singing beneath us.

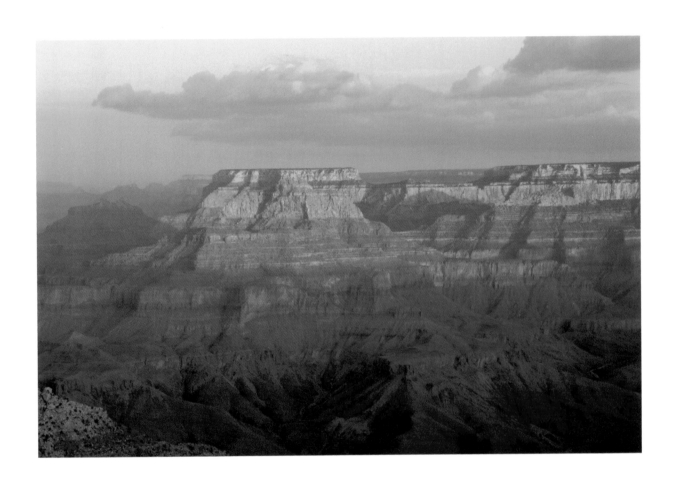

I have kept this landscape
to myself long enough,
its tremendous storms,
its shelves of red and lavender,
sunlight telling time
on rock, rock receiving water.

Come to the edge
of your mind, open.
These are your real parents.
This is the ancient road
that leads true North.

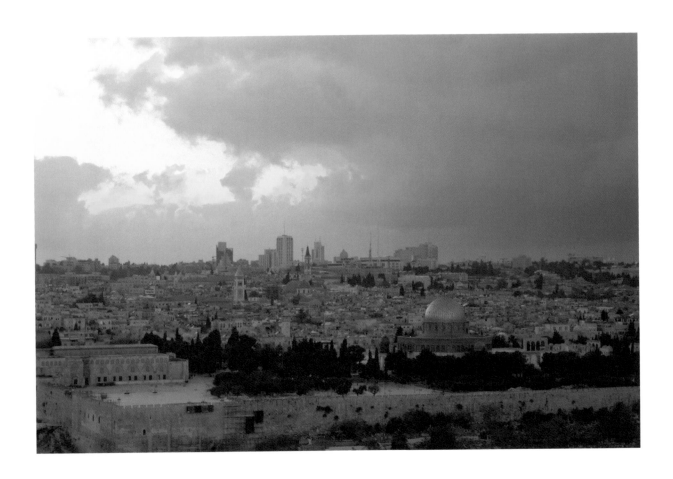

This hill is my heart.
I know that
because last night
I dreamt lights

like a hive buzzing
above a loaf,
all the bees
coming home.

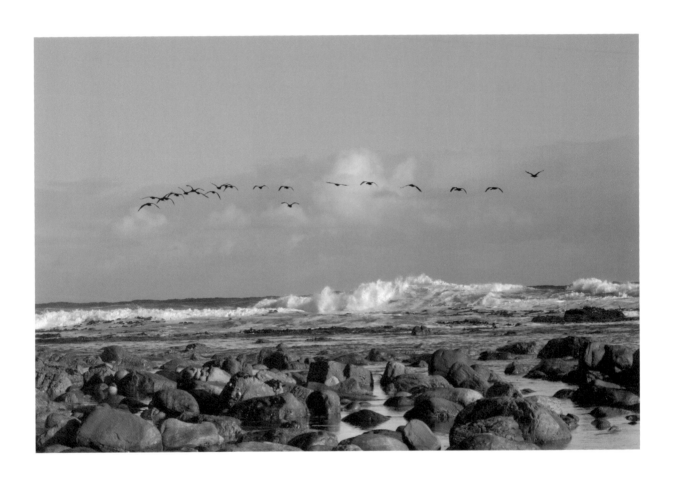

43

The birds return,
the sea returns.
I raise my arms

in welcome, my
circling self landing
on the shore of time.

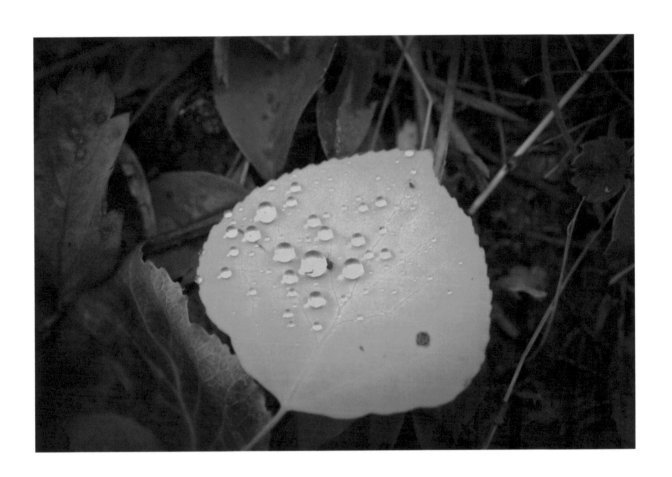

I wasn't always
a water planet,
not always poised
on this leaf of a dream.
But loving you

is easy, and
nothing you thought
you could dream
against me
could ever come true.

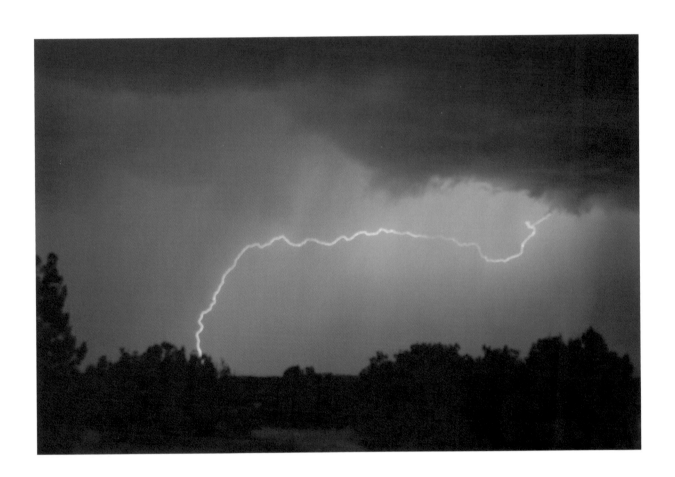

I, reaching for you;
you, reaching for me,
the jagged arc
of our excitement.

Who could have thought
this charge of longing
in the heart, the joy
of forgetting and remembering?

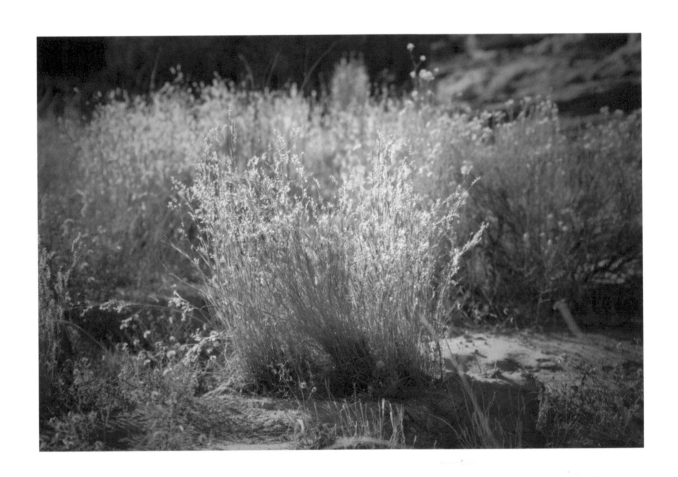

This is where we meet,
where love grows,
where corn rises to the sky,

this marriage of lights,
these tassels in the sun.

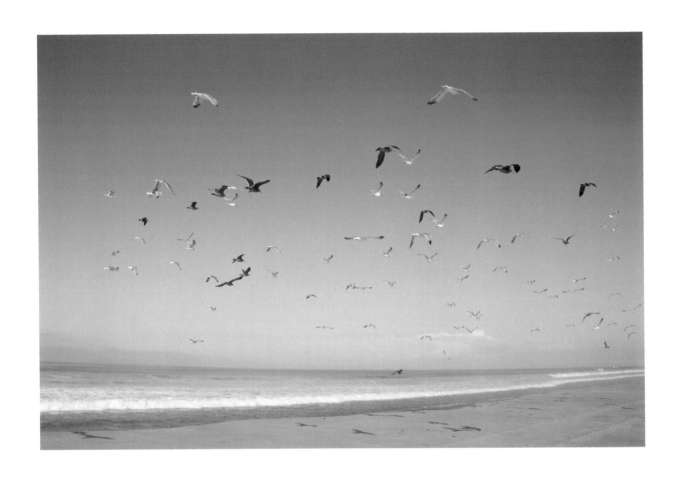

We walk and talk
and sing to each other,
then we fly up and over,

giving ourselves
to wind, to movements
of sun and water,

to the great wing
within us.

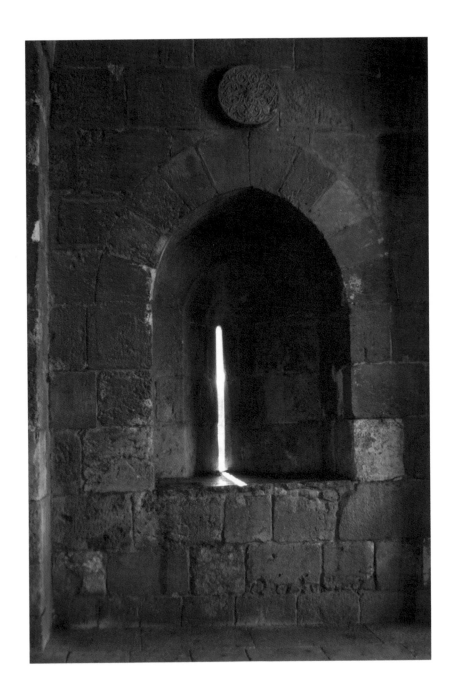

I did not come
to worship walls
or things, but
to extend
that which I am.

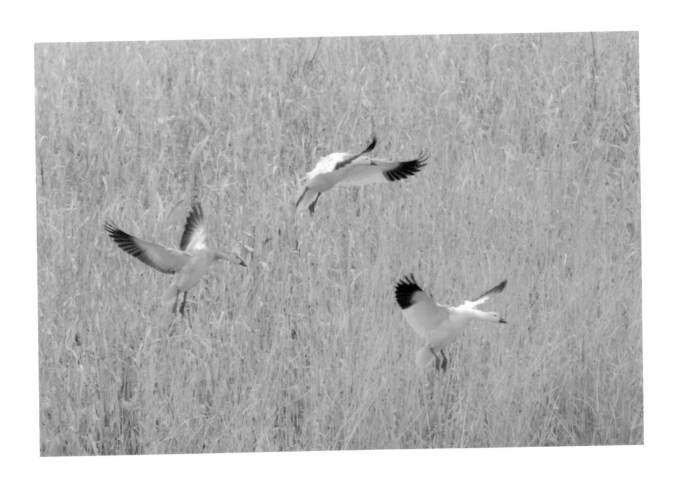

I'm already in love
so I'm not sure
what to call this;

your hands like wings
showing me how it goes,
opening, opening…

spending all morning
breathing as one.

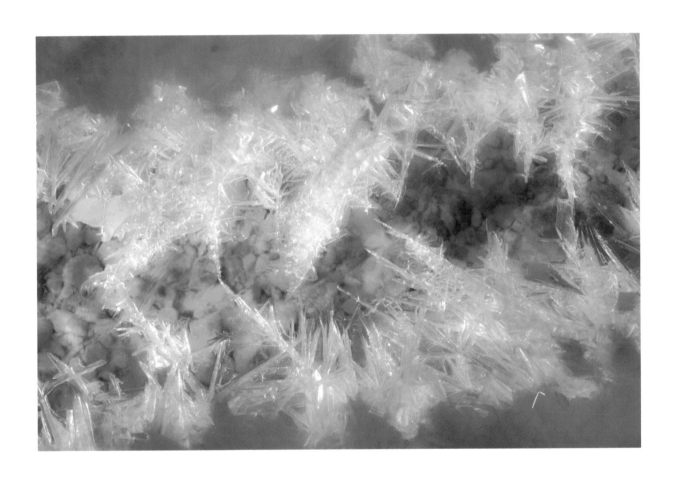

The word
rising from every
given thing, the light
from the inside out.

Where we meet
I have no name,
nor need for one.

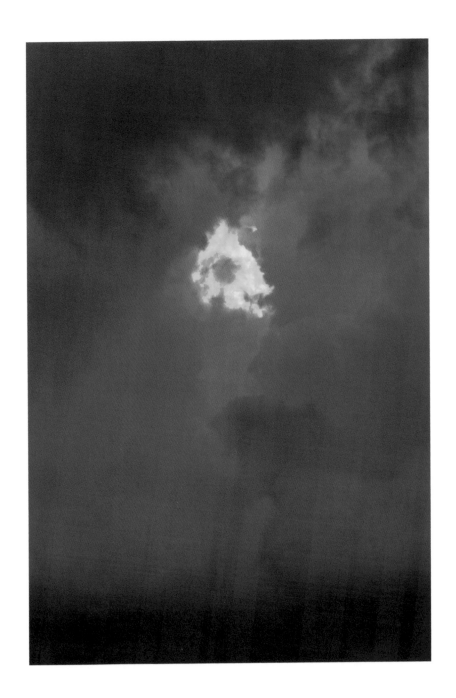

I asked the fire,
Before this flame, what?
I asked the water,
Before this wave, where?
I asked myself, Who?

I tried to imagine
this amber light
and tilt of horizon
as it might have been
or might yet be, but
again and again, just this.

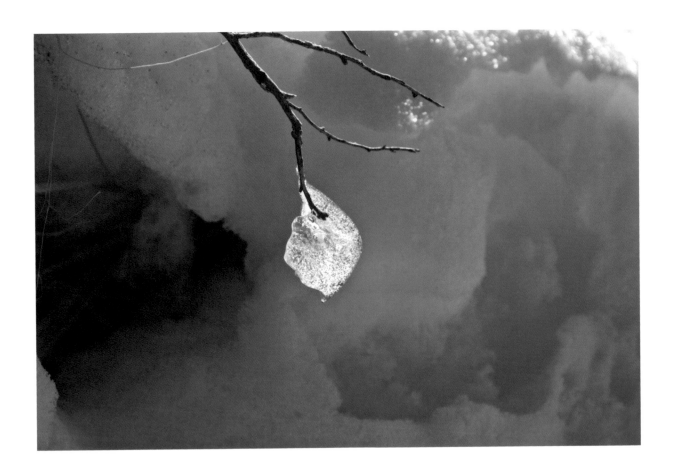

It begins to flower;
it begins to decay,
and in between
it and *begins*
I am the watcher.
Come,

let's walk together;
I have more to show you.

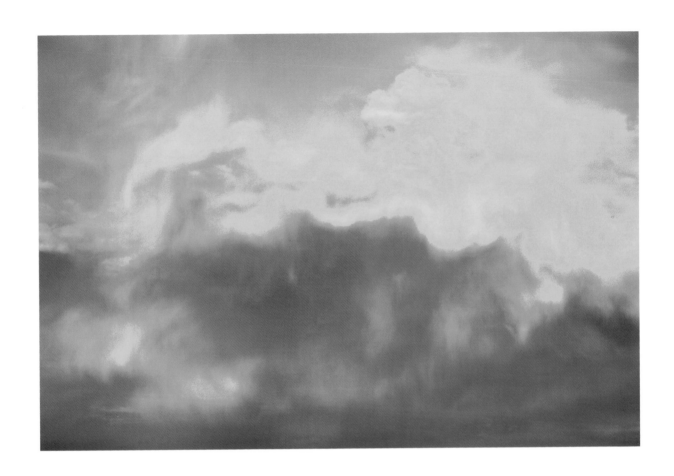

This cup of water,
this precious cup
I have carried
across the desert

to offer, to empty—
all travails
burning like a mist
in the morning.

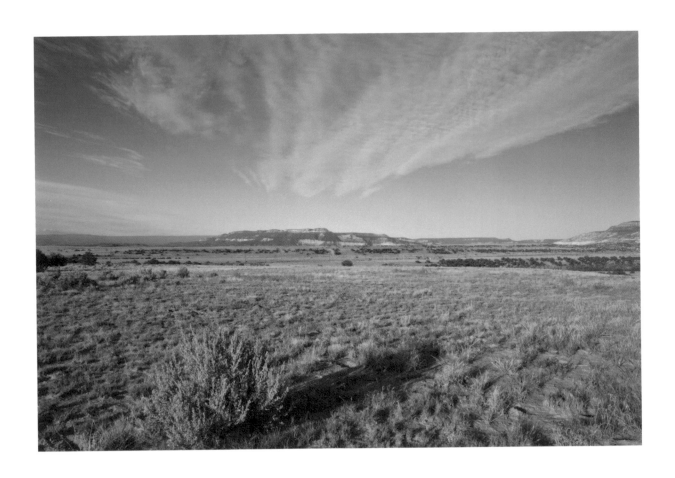

Bored with my own stories of creation
I smashed the clay pot
belonging to my family
and walked, not into a mythic
or metaphoric desert,

but straight out my back door
into whatever wildness
lay beyond this
so called body of knowledge.

Index of Images and Poems

photo Carolyn D'Alessandro

Having a deep connection to Nature, I have always seen details, beautiful patterns in the seeming chaos. It has made photography frustrating at times because I could not capture that which had attracted me. It is my passion for photography, though, that is teaching me slowly how to translate this seeing into an image. Today, my goal is to express essence in my photos.

Finalizing the selection of the images to go with the poems became a review of my photographic journey: from the big landscape to the more intimate view of it. About a year ago, I began saying: "My photography is changing". At first, I saw that the images took on a different quality. Now it has more to do with the awareness of how my seeing is changing as I build relationship with a place. Again, it is moving from taking in the big vistas to the more intimate view, to embracing the details.

This reflection on relationship, not unlike life, leads to deeper understanding. I found the expression of this understanding in Stewart Warren's poems, which eventually lead to this book. The collaboration has been such a delight. I appreciated his openness to selecting a different photo as I sat with the poem he wrote, as well as 'tossing' me a poem with the comment: "This one needs an image." In the final stages, time flew working in a combination of focus and laughter. Each one's creativity was fed by the playful expression of ideas. We were like kids on the beach building a castle.

Corinna Stoeffl
Abiquiu, New Mexico, 2010

There is a type of "seeing" that I believe we all possess, perhaps more predominantly when we are children or during so-called peak experiences, but always available to us. For me this "seeing" is visual but also encompasses feeling and even a certain knowing. But not an intellectual knowing, not an idea game or something to think about.

photo Carolyn D'Alessandro

All my life I've been haunted by a longing to give expression to this view and viewing of the world, to this direct experience of relationship with that in which I live and have my being. I chose language, so I picked up the very tool that by its nature obscures that which I hope to illumine. It's hopeless, and I'm doomed the moment I begin.

I could not hope to capture all the moments I'm privileged to experience, nor would I care to. But I do endeavor to create a kind of *wordart* with the intention of giving others the opportunity to enter into this "seeing." I use texture, rhythm, pattern, metaphor, anything. I use words and phrases like pieces of string or bark brought back to build a nest. I'll spend as much time as is warranted unhinging the mind, creating opposites and angles that confuse reasoning and lead to an opening. I want your trust and surrender. What happens next is none of my business. How could it be?

I have been happy indeed to join in this collaboration with Corinna Stoeffl. For me, her images are about relationship, not objects. She totally gets it. In our work together I have been able to let her guide me in her own way into that "seeing" place. We're like kids with mud and sunshine and an endless afternoon. Each element or design consideration became another opportunity to "enter in." Perhaps it is truly as a friend once said, "It's not what we're looking for, but what we're looking with."

Stewart S. Warren
Northern New Mexico, 2010

Notes

Notes

Notes

LaVergne, TN USA
09 April 2010
178660LV00001B